ALL THAT MATTERS

ALL THAT MATTERS

The Texas Plains in Photographs and Poems

Photographs of the Southwest Collection Selected by
Janet M. Neugebauer

New and Selected Poems by
Walter McDonald

Texas Tech University Press

This book was set in 11 on 15 Palatino and printed on acid-free paper that meets the guidelines for permanence and durability of the committee on Production Guidelines for Book Longevity of the Council on Library Resources.

Printed in the United States of America.

Library of Congress Cataloging-in-Publication Data
McDonald, Walter.
 All that matters : the Texas plains in photographs and poems / new
and selected poems by Walter McDonald ; photographs of the Southwest
Collection selected by Janet M. Neugebauer.
 p. cm.
 ISBN 0-89672-291-0 (alk. paper)
 1. Plains—Texas—Poetry. 2. Plains—Texas—Pictorial works.
I. Neugebauer, Janet M., 1935- . II. Texas Tech University.
Southwest Collection. III. Title.
PS3563.A2914A79 1992
811'.54—dc20 92-16575
 CIP

92 93 94 95 96 97 98 99 00 / 9 8 7 6 5 4 3 2 1

Texas Tech University Press
Lubbock, Texas 79409-1037 USA

ACKNOWLEDGMENTS

I'm grateful to the following publications in which these poems first appeared, some with different titles:

Agni: "Rock Softly in My Arms"

America: "Feeding the Winter Cattle"; "Night Missions"; "Taking Each Deep Breath"

American Poetry Review: "Whatever It Takes"

Ascent: "A Brief, Familiar Story of Winter"; "Drying Up"

Atlantic: "The Goats of Summer"; "Hawks in a Bitter Blizzard"; "Wind and Hardscrabble"

Beloit Poetry Journal: "Rig-Sitting"

Chariton Review: "Seining for Carp"

Cincinnati Poetry Review: "Sundown"

College English: "Finding My Father's Hands in Mid-life"

Concho River Review: "Tornado Chasing"

Confrontation: "Building on Hardscrabble"

Country Journal: "Cattle in Rain"; "Double Mountain Fork of the Brazos"; "Making Book on the Aquifer"; "Uncle Bubba and the Buzzards"

Cross Timbers Review: "Trains, Up Close and Far Away"; "Whatever Ground We Walk On"

Descant (USA): "Prairie Dogs Live in Lubbock"

Galley Sail Review: "The One That Got Away"; "Sandstorms"

Gettysburg Review: "Uncle Rollie and the Laws of Water"

Great River Review: "Alone in a Windstorm"

Images: "Praise"

Journal: "Plains and the Art of Writing"

Kansas Quarterly: "The Digs in Escondido Canyon"; "The Eyes in Grandfather's Oils"; "Living on Open Plains"

Kenyon Review: "The Winter before the War"

Mississippi Arts & Letters: "Black Wings Wheeling"

Mississippi Review: "At the Football Stadium"

Mississippi Valley Review: "After a Year in Korea"; "Father's Revolver"

Missouri Review: "Mounds at Estacado"; "Old Men Fishing at Brownwood"

New England Review: "On a Screened Porch in the Country"

Northwest Review: "After the Flight Home from Saigon"

Oxford Magazine: "Setting Out Oaks in Winter"

Poet Lore: "Driving Home to the Plains"; "Tied Up under Trees"

Poetry: "Losing a Boat on the Brazos"; "Memento Mori"; " Starting a Pasture";
 "When Children Think You Can Do Anything"
Poetry Canada Review: "A Woman Acquainted with the Night"
Poetry Northwest: "Where the Trees Go"
Prairie Schooner: "Deductions from the Laws of Motion"; "Mercy and the Brazos
 River"
Puerto del Sol: "Out of the Whirlwind"
Sam Houston Literary Review: "My Brother in Summer"
San Jose Studies: "Windmills near Escondido"
Scrivener (Canada): "Home"
Sewanee Review: "Settling the Plains"
Seattle Review: "The Night of Rattlesnake Chili"
Southern Poetry Review: "Blue Skies"
Southern Review: "Fiddles and Steel Guitars"
Spoon River Quarterly: "Witching on Hardscrabble"
Tar River Poetry: "Marriage"
Three Rivers Poetry Journal: "Wildcatting"
Threepenny Review: "Weeds, Barn Owls, All Nibbling Goats"
Visions: "Getting It Done"
Willow Springs: "Dust Devils"
Windsor Review (Canada): "After Eden"; "Growing Up near Escondido Canyon"

"Wind and Hardscrabble," "Hawks in a Bitter Blizzard," and "The Goats of
Summer" were first published in *The Atlantic,* copyright 1985, 1989, and 1990 The
Atlantic Monthly Company. "The Winter Before the War" was first published in
The Kenyon Review, copyright 1987. "Memento Mori," "Losing a Boat on the
Brazos," "When Children Think You Can Do Anything," and "Starting a Pasture"
first appeared in *Poetry,* copyright 1984, 1987, and 1991 the Modern Poetry
Association. "Deductions from the Laws of Motion" and "Mercy and the Brazos
River" are reprinted from *Prairie Schooner,* by permission of University of Nebraska
Press. Copyright 1991 University of Nebraska Press.

I'm especially grateful to editors who published earlier books with many of the
poems included in *All That Matters.* Special thanks to Texas Tech University for
faculty development leaves and to the National Endowment for the Arts for
fellowships which provided time to write many of these poems.

 WM

Most of the photographs in *All That Matters* were reproduced by Roger L. Wilkins, Electron Microscopy Center, Texas Tech University Health Sciences Center. Darrel Thomas, James T. Matthews, and Walter Granberry, III, also contributed their photographic talents to this project. H. Lucette Sheppard was invaluable in retrieving photographs from Southwest Collection files. Even though it hardly seems adequate, a Texas-sized thanks to all.

<div align="right">JMN</div>

The Southwest Collection, a history research center on the campus of Texas Tech University, collects and preserves the history of West Texas and the Southwest. The physical memory of this region is found in personal papers, diaries, oral histories, business records, and photographs. Since its beginning in 1955, the Southwest Collection has collected more than 300,000 photographs that researchers from throughout the world use to gain insights into the past, present, and future of the American Southwest.

CONTENTS

1
Rigging the Windmill

2
Growing Up near Escondido Canyon

5

Weeds, Barn Owls, All Nibbling Goats

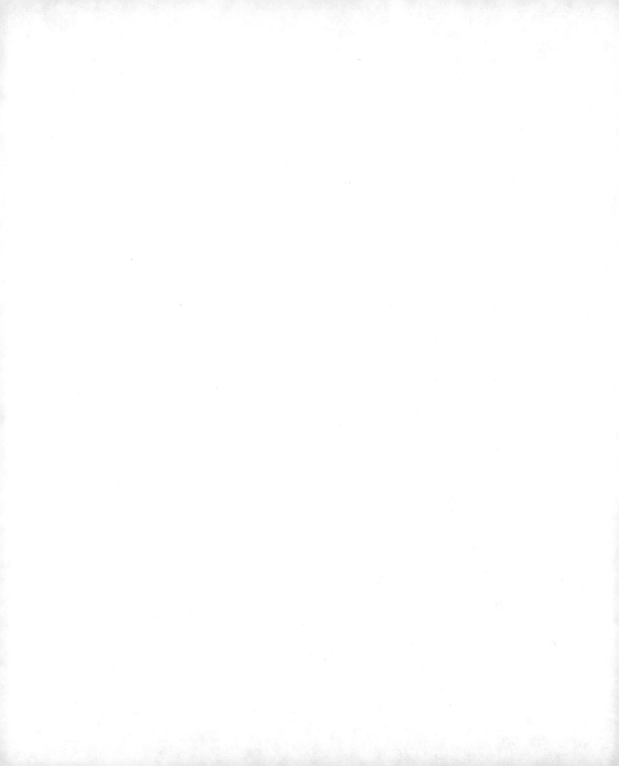

1

Rigging the Windmill

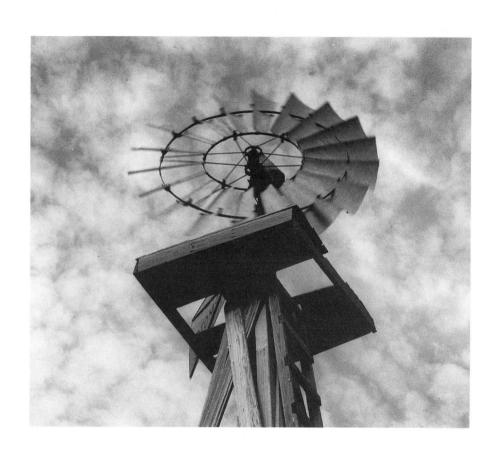

Wind and Hardscrabble

It's wind, not rain, dry cattle need.
Vanes of windmills spinning all day
turn lead pipes into water.
Wind makes metal couplings sough
like lullabies. As long as there is wind,
calm steers keep grazing, believing

there is always water. On still days
steers are nervous,
lashing their tails at horseflies
always out of reach. They stomp
flat hooves and tremble, bleeding,
and thrust their dehorned heads

between barbed wires. When it blows,
steers don't need heaven.
Wind is mystery enough.
They rasp dry tongues across salt blocks,
eyes closed, and wind brings
odors of grainfields miles away.

Even in drought they feast,
the curled grass crisp as winter stubble.
Parched, they wade still pastures
shimmering in heat waves
and muzzle deep in stock tanks
filled and overflowing.

Starting a Pasture

Flooded with sun, this ranch looks like a rice field,
a trick of optics. Rattlers roam boldly,
natives as foreign to our ways as wolves
which disappeared by 1880.
Surviving coyotes sway in ballets for the moon,
heads back, worshipping only heaven. We mete out mice
to cats and owls, fat on our grain sacked up for cattle.

Stuttering owls cough softly in our sleep
like goats, another herd we're saving. Neighbors
drive slowly by and stare, their windows tight.
They scoff, although we're feeding thousands,
cabrito and Texas mutton worth more than beef.
Let them laugh while little bells lead lambs and goats
to market. All week we find our cows,

heads down, praying to all the stubble they own.
We fill their troughs and call, and they come
floating through a lake of shimmering sunlight.
My wife's green eyes play homespun

when the chores are done, better chords
than fiddles and sweet guitars. After a rain,
fat cattle wade alfalfa ankle deep.

Often in our fields I find buzzards,
too late to save a calf I would have gladly fed.
My sons ride the range to keep them airborne.
Let cattle claim our pastures,
let lambs turn into wool, let buzzards
wait for city dogs tossed out of cars.
This morning I found a tow sack full of kittens.

They'll grow up gladly in our barn,
making the owls work harder for their mice,
saving our wheat for export. All winter
we sow alfalfa for livestock, two of each kind
in a starving world, buffalo imported
from Wyoming, a flock of ostriches which came
last night by train, wide eyed and panting.

Black Wings Wheeling

I've seen her lift a calf
half starved, lost in a thicket,
carry it twisting between mesquites
from cow to cow until one
full uddered and lazy
would take it. She believes

nothing should be alone for long.
Every drought, we find buzzards
stacked in a spiraling cylinder,
red heads and fanned black wings,
tip feathers pronged like knives,
coasting, waiting for something to lie down

under a black circling mobile
and close its eyes. Grass stubble
clings to caliche, crackles when anything
tries to run silently away—
lizards with slit mouths, lost dogs,
does with wild eyes and rapidly beating hearts.

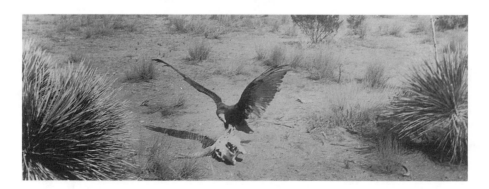

Whatever It Takes

In Pakistan, three elephants go around
and around a hill, crushing an avalanche of limestone,
men ten feet below seining for emeralds.
Three shirtless men go up and down the necks
of elephants all day, their ribs like xylophones.

In Spain, men crouch through vineyards that go up
and down over the stones of mountains.
They gather grapes like emeralds, like amethysts.
Later, they crush them under their feet.

In Arkansas, men pay two dollars each
to stalk the public hills
head-down, hoping for diamonds, for opals,
for whatever the earth delivers.

In Carlsbad Caverns, bats upside down in the dark
of day build hills of guano.
By night, men wired with headlamps scoop
tons of nitrogen like rubies.

Near Matador, a man dismounts, drops the reins
and his horse stands dreaming. Defying snakes,
he stoops by a cactus, lifts and carries two stones
to the barbed wire, drops them

by a tilted fence post, jerks it straight,
shoves one stone then the other
to prop it, stomps down around this post
to wedge it tight between two perfect stones.

After the Flight Home from Saigon

This is the rage for order on the plains,
barbed wires from post to post.
Fat cattle are in the fields,

all fences tight. Daily I ride
eight thousand acres and pretend they're mine.
My sorrel's boss of a herd that knows it.

He's never killed a bull, keeps no money
in the bank, sings no soft gospel songs
at sundown. He's twice, three times the man

I am, but look who rides him. With this right hand
I tap the reins which turn him. I led him
through paces as a colt, held his head

while the vet made him a gelding.
He's much too tame to buck, to back talk
any nudge of my boots. Slouched in the saddle,

I promise him sugar cubes, oats after work,
a round corral and a stall with straw
in bad weather, not far from my door,
each day laid out for him, easy to understand.

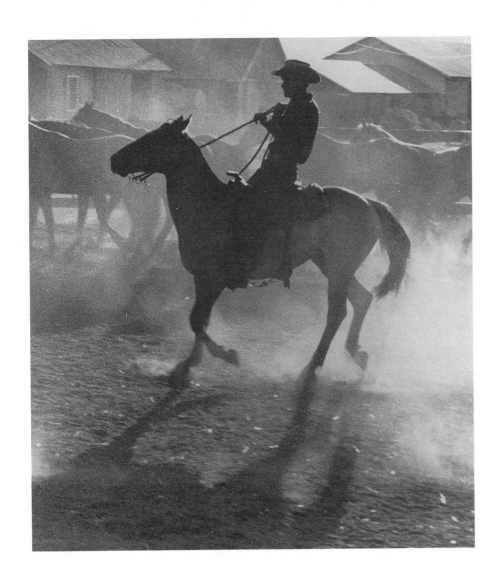

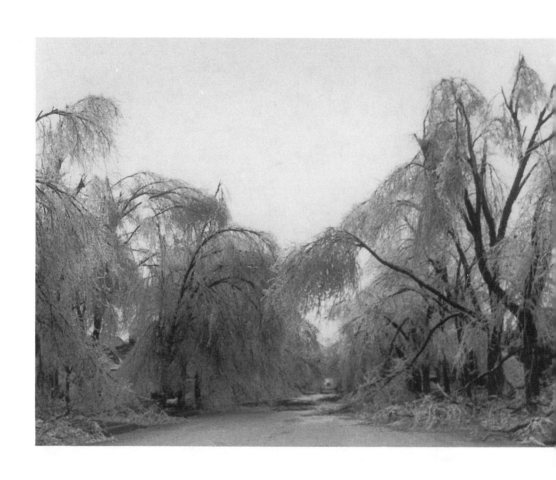

Hawks in a Bitter Blizzard

Hard work alone can't drive blue northers off.
Nine blizzards out of ten blow out
by Amarillo, nothing this far south

but flakes and a breeze to make a man
in shirt sleeves shiver. Every few years,
Canada roars down, fast-freezing cattle

in the fields, dogs caught between barns,
hawks baffled on fence posts. Stubborn,
hawks refuse to hunker down in burrows

with drowsy rattlesnakes and rabbits.
They drown in their own breath-bubbles,
crystal as the sheen on barbed wires

freezing in the rain. Wood carvers driving by,
grinding on chains down icy roads,
see them at dawn and envy, tempted

to haul the fence posts home and burn them,
nothing in oak or juniper they carve
ever as wild and staring as those eyes.

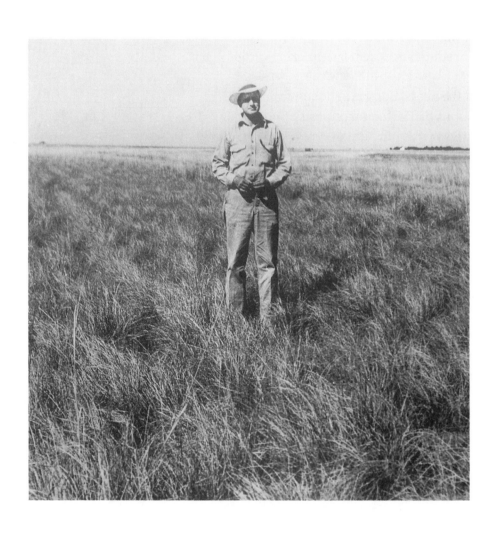

When Children Think You Can Do Anything

Living on hardscrabble, a man is less
than a wolf and knows it, carries a rifle
in season or not. Out here, killing's
always in season, time enough for scruples
sweating in bed with the windows raised.

I hear my kids kicking their sheets.
Like good kids, they blame the heat.
I feel my wife's heat inches away.
They sleep with only me to protect them,
nothing outside I haven't tracked for years,

bobcats and wolves, rattlers that coil
under our trailer like tribal gods.
I'm paid to patch fences around a range
nothing but goats and cows could graze.
I keep the stock tanks full, the buzzards hoping.

When cows stray down arroyos, the wolves
are sure to follow, circling a calf too weak
to waddle. If I can drop one wolf by moonlight,
the others tuck-tail and run. If I'm late,
next morning I drive the cow out

wide eyed and frothing, her full bag swaying,
mesquite and cactus wedging us apart. That night,
I splash my face a long time at the pump
and comb my hair and shave, roll down my sleeves
and go inside as if nothing's happened.

Windmills near Escondido

Relax, it's Friday, nothing to do
but beat the ground until iron weeds
are dead, the hoe filed silver-thin,
gloves frayed and molded to your fists.

Grow sorghum when it rains and feed a prairie
black with steers, fat Angus glistening
like whales. This year, our dry steers
stumble to the barn at sundown,

coughing, jaws grinding side to side
their latest cud. This is a week,
eating red meat, praying for rain,
kicking chalk-white caliche dust

to tanks moss green and empty. Climb up
and grease the windmill bearings
one more time, connect the rods
and duck below the rudder

swinging with the wind. Climb down
and watch the tanks fill up,
shove back at cattle nudging to the pump
like pigs, stiff wind more mercy to the steers

than rain. Buzzards keep watch on us all,
lost in a desert. Our runty stalks
dry up and burn. At noon,
we watch pepper clouds on wide horizons.

Cold beers condense more moisture for our fields
than clouds. We feel like hawks
scouting the skies, hoping to make dry dust
give up ideas like coyotes loping to the caves.

Squinting, shooting black buzzards
with our fingers, we face the sun and wonder
how many gallons spin on a windmill,
how many rain clouds wishes build.

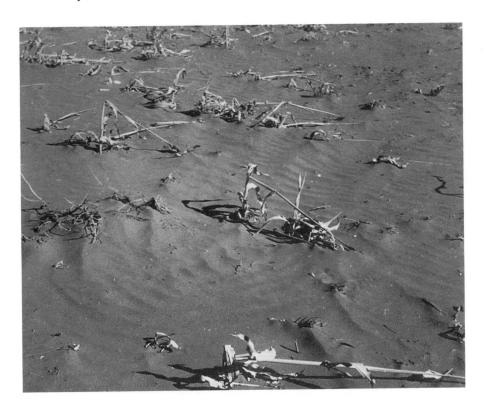

After Eden

I like snakes my own way, underfoot,
not overhead in branches draped like vines.
High on a sorrel clopping on iron shoes

I see them often at a distance, slithering away
on their bellies between mesquite and cactus.
This is the grace of hardscrabble,

prairie where no trees grow native,
nothing sweet the old serpent
can dangle from a limb.

I watch one disappearing down a hole
and pity prairie dogs. Stopped at a steep arroyo
looking for strays, I prop one leg

across the saddle horn, strike a match
on a boot and touch it, smoke the one thing
dryer than the breeze. I see a steer

grazing below, but let it taste its last meal
before the slaughterhouse. I finish the butt
and crush it on my boot, and flip it,

shove that boot back in the stirrup and flick
the tip of the reins to nudge the horse
downhill. The steer sees me and stares,

chewing the last good weeds in a canyon
where it hasn't rained in months, too dumb to know
I'm a death angel come to drive him

with yells and a rope uphill to the pasture
where the loading corral is waiting
and a truck backed tight against the ramp.

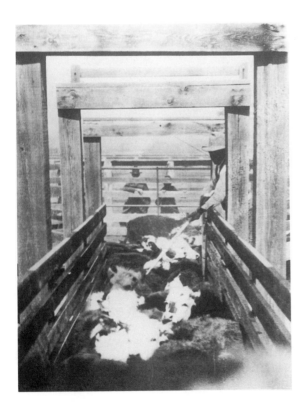

Fiddles and Steel Guitars

Even a stuttering owl knows music
piped under rafters in the barn.
Work goes better with a radio
like Saturday-night cafés, hay bales
too heavy without a woman sobbing
heartbreak in a song. Stacked high,

they'll feed the cows all winter
when it snows, enough stored grain
to take them through to pastures
in the spring. This is the year of the bull,
the year for breeding better calves.
Sacks of grain are nothing

to bulls stalled in the barn,
dreaming of the heat of summer,
the songs of other fields.
Two old cousins in a boat
can't keep a secret. We sing, we brag
about old girlfriends over water, standing up

and swaying on the lake. Barbed wires
on rusted nails can't hold mad bulls
when they hear cows rehearsing lullabies.
A bull would kill for music odd as that.
Slowly, a bull's eyes open to the threat
of men a tenth his size holding out their hands,

this box of ordinary noise no louder
than the tunes he hears between his horns.
The danger more than horns is boredom.
Hard work can't drive old longings out
when we hear others sobbing. Not all things
care for heartbreak, not one sullen hog

runs grunting through the mud. In time,
all music stops, but now the farm's alive
with fiddles and bitter-sweet guitars,
the twang of someone sobbing sad good-byes
and a mad bull backing off and pawing,
about to tear down the barn.

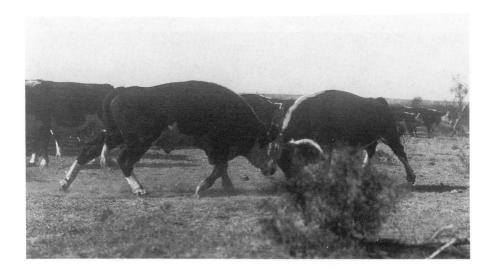

Memento Mori

I've seen her pose a skull
on a barrel cactus she has cultured
in sand like caliche, the pulp thorns
sprouting like bristles
on the waxy face of a husband.
She tilts the white bone, searching
for shadows like eyes in the holes,
the wide horns the only signs
about the skull suggesting cow.

With the bristles of horses
she brings out of canvas a desert,
driving down trails she invents
thousands of cattle she raises
from dust, hiding their dry, durable
muscles under nothing but paint.

And here on a desert in Texas
she has lacquered a slab
of an oak tree, mounted it
like a corral on a living-room
wall, brushed out of nothing
a thorn-barreled cactus
wearing a skull, painted in clouds
and ground we could stand on.

Cattle in Rain

No cow knows what to do in rain.
Grackles dive for the trees
and chickens flap for the barn,
squeezing their wings and waddling.

Caught in the fields, cows
shove their muzzles down
and graze. Something in the sky
is falling. Their round eyes glaze,

and everywhere they stare
is green. They never blink,
they drop their dished heads
down and grind off all grass

they can reach. They believe
when it is time to lie down
in the pasture, they will go on
chewing this green haze forever.

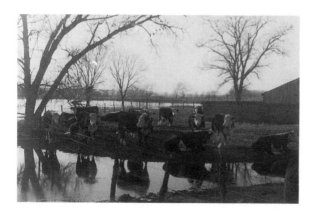

Taking Each Deep Breath

Rain, the long arm of thunder, reaches us
at last. After months of drought
and shimmering mirage, so much staccato fuss
to make one pond. Steers wade the mud

and stare, lower broad muzzles into floating grass
and shut their eyes, and why not,
about to be hauled off in trucks
when the rain stops. Propped on the back porch,

we watch a prairie fade in a squall line,
hard rain like the days of Noah. The breeze
is fresh honey in the hive. We are two bees
in a pasture. The steers go under in the haze,

even the barn, only this porch swing
dry in the downpour, an ark we rock on,
gliding under the crack of thunder,
taking each deep breath to let it go.

2

Growing Up near Escondido Canyon

Trains, Up Close and Far Away

Hearing a faint train whistle
miles away, I feel thunder
shaking the ground in the country.
Rails rang when we knelt and listened

to wheels singing to Houston.
Pennies we spread on the rails oozed
smoother than communion wafers,
coppers we paid to see brown metal

mashed to gold. We slept outside
some nights, ducking under quilts
from bats flitting by to the river.
Giant trains crashed by us, engines on fire,

about to explode. We hunted mashed coins
by flashlight and heard shrill whistles
wail long after any human hand
could have pulled the cord.

Growing Up near Escondido Canyon

With bristles and picks
precise as diamond cutters,
they chip two hundred years a day,
tagging snake bones and buffalo, bowls
and amulets of teeth.

Here in caliche they've found five flints
buried twelve thousand years,
nothing on either side for centuries
as if they killed each other off,
not even small-boned rabbits,

layer after layer like diamonds
malleted at bad angles and shattered.
Growing up a mile from here,
I raced my brother
over the plains,

hawks on bent wings
gawking at us, dipping and sidling
on summer thermals.
Years before diggers climbed down
these cliffs, we made up lies

at night—murders, something moaning
across the canyon, bodies
buried in shallow graves,
dug up by dogs and eaten.
My brother found the bones.

In moonlight, trying not to shiver,
afraid our father would catch us
sneaking home,
we huddled by a stick fire
cursing, smoking bark cigars.

Midnight, thinking of what we'd found,
we held them up to the moon,
cows' bones or coyotes'
we believed were human,
turning them over and over.

Double Mountain Fork of the Brazos

Living on stones and runoff from rain
that rarely comes, this fork in forty miles
drains dust, dry mouth swearing
all it owns to the Brazos.

Whoever named it liked romance,
mountains two hundred miles away,
nothing where it begins
but a sudden drop-off in a field,

a sinkhole twenty feet across.
I've stood there, seen
a mighty river start, if I believed
in names. I've backpacked forty miles

and never found a stream so deep
I couldn't step across on stones.
I slept under train trestles so low
I almost bumped my head.

I named creatures living on nothing
but each other, coyotes and skunks,
owls, rabbits with wide eyes,
a thousand diamondbacks.

Feeding the Winter Cattle

We lifted bales and dropped them heavy
from the wagon. Hay burst like melons,
even on a cushion of snow. Plodding,

a bossy cow took charge of each split bale,
head down, her long horns hooking air,
her purple tongue sucking the bale like a melon.

Dumbly, the others followed, bobbing their heavy heads.
Stark sunshine made me squint, watching a hawk.
The dogs weaved behind the wagon, panting,

sniffing for tracks, wetting the wagon
when it stopped. The mules didn't care,
stubborn as if asleep in their harness.

Grandpa coaxed, "Please, sir, Big Ed.
Once more for daddy, Lou," tapping black reins
like a love pat. And bump, we'd lurch again,

my little brother and I grabbing for balance
on floor boards slick with straw,
stabbing our gloves into another bale

and lifting, heaving it over like ballast
between the dogs, like another Christmas visit
dropping away forever.

The Honey Man

Like a bear, Uncle Murphy could line bees
straight to the hollow heart
of a sweet gum. He followed,

crammed his fist in up to his eyeballs
and peeled off bees sticking to honey.
No bee could sting him worse than mosquitoes,

weaned on honey, honey always on his table.
Hives like salt blocks rubbled his pasture,
each with its own rare flavor. Uncle Murphy

knew by taste which neighbors added lime
to their clover, whose alfalfa was runty.
When we dared, we slipped between split rails

and tracked him over a wood culvert
always sagging, weaved through his acres of hives
to the still. He sold corn liquor and honey

in fruit jars, whatever taste you craved—clover
yellow as butter, dark bittersweet mesquite,
white lightning, sweet copper combs.

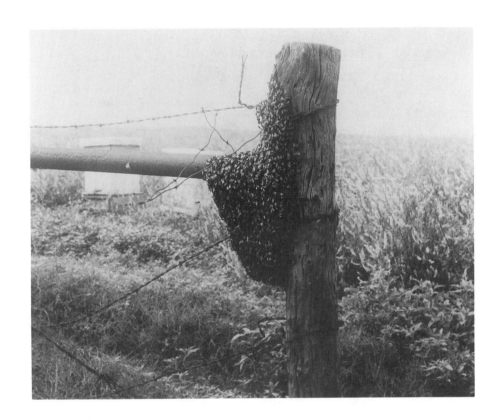

Uncle Bubba and the Buzzards

Old Uncle Bubba wore scuffed leather
molded to the foot. He shoved old boots
through stirrups made for work and rode a horse
as if it owned him, half-horse, half-lariat
twirled above a leather Stetson. Bubba never
wore spurs, kicked only boots to his gelding.

Gloves he wore to brand castrated bulls
were second skin, the bloody way it was.
He never bought tobacco, half the time broke.
Deep in the pasture, he'd lean from the saddle
to borrow my sneaked smokes. I remember
his whiskey nose, his white mustache,

the way he taught me to ride, bouncing
behind his saddle, holding on.
When Bubba rode alone down steep arroyos,
buzzards dipped their wings good-bye:
if it was a calf, he'd find it.
I'd run out while he climbed slowly down,

old leather creaking. The calf wobbled off
to find its mother, and Bubba hobbled,
letting me lead his horse to the corral,
his leather chaps zipping like corduroy,
sweaty glove rubbing his horse,
his stiff boots thudding in the straw.

Father's Revolver

I carried it cold, with pearl handles.
Behind the outhouse, I spun the gun like a cowboy.
Rabbits die because their world is full of rattlers.
They run from boys with their fathers' revolvers,
but not far. I twirled that silver pistol

until I seldom dropped it, spinning it over and over
and plop, into the holster—the fastest gun in Texas.
I thought now it begins, the endless cycle
of gunfighters. I dreamed my aim could save me,
the heavy Colt not cocked but loaded. I believed

the secret was simply to draw, certain I could drop
actors in black hats wide as barns. Spitting
on weeds, I tossed a fruit jar up and pointed,
bang! I said, and it exploded. Tilting the pistol,
I blew as if the cold barrel smoked,

as if I'd shot. Lifting it up, I studied
the snub tips of bullets like secrets of girls
covered by silk or cotton. I rolled
the cylinder and watched each bullet loaded.
I knew my father would hear, but I could say

backfires of cars on the dirt road, not thinking
there'd be no plumes of dust for miles. I groped
both thumbs to cock it, waving it like a wand
over the pasture, coaxing rabbits to hop boldly
in the open, daring rattlesnakes to coil.

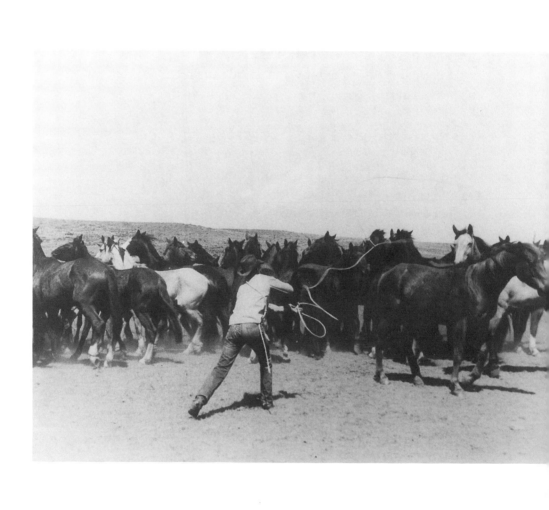

The One That Got Away

We took turns eating ammonia dirt,
Billy Ray and me and big Joe Bubba,
bucked off in the corral, dying to tame
the tiger springing under us with hooves,
broad muscles bulging the saddle loose.

That horse would make a champion palomino,
tamed, a showboat stallion, prancer in parades.
First one to ride could have him,
old Uncle Oscar swore, his bad back stiff,
or he'd have broken it himself.

How many times did Slick buck us,
how many kicks to our heads,
just missing? After split lips
and sunburns, we turned him loose,
the deal we made with Uncle Oscar. Cursing,

loving that stud like no other, we swore
we'd find him again when we were older,
him and his harem of mares. After we finally
flicked off the reins, after Joe Bubba
let down the gate, Billy Ray coaxed

that palomino until it bolted away
out of the dust and horse dung,
free over the wide dry prairie,
four hooves in the air forever,
his mane like flames of gold.

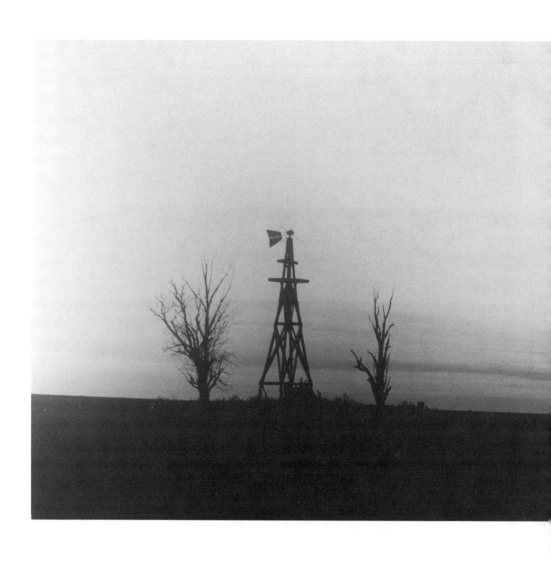

Uncle Rollie and the Laws of Water

The windmill pumps an old, slow action up and down,
like making prairie love for water. Fat cattle
worshipped a trough Rollie kept full on flat plains
made for coyotes. He shared with farmers getting started,
let them open and close his gates to haul sloshing barrels
in wagons, helped dozens dig their own sweet water wells.
He taught me to draw, that perfect slap of leather,

the bang and wavering whine across a mile of pasture.
I needed what only he could offer, a horse to ride,
a thousand acres of rabbits, tales of range wars
and buffalo. But I was ten and he was sixty,
old as heroes in the Bible, childless like Abraham,
Aunt Mary dead before my older brother was born.
When Rollie died, steers wandered these acres

like a desert, getting fat for an absentee landlord
who must be dead. The last barbed wires are down,
the whine of buzz saws building imported lumber,
his pasture sold as tracts for houses. This windmill
is the last he dug, the stock tank shot by rifles,
the water trickling through a rusted pipe, faithful
after all these years, the dry, split blades still turning.

Wildcatting

In the cramped cab of a pickup, we bump down
caliche canyons between mesquite and cactus,
following hunch and arroyos more than maps.

Whatever covers oil is old and barren,
dry riverbeds, patches of bone-white alkali,
outcroppings of granite,

a billion barrels ours for the drilling.
Nothing is there until we find it.
We believe in steel bits and stone

and twist our wrenches tight,
drunk on the constant spinning, each twist
of the bit like love, trying it over and over.

Rig-Sitting

On the derrick, I twist this wrench tight
as if the oil pipes of the world depended
on it. I clear myself and signal,
and down below, the clang
and rattle of chains begins,
the drill bit biting miles through bedrock.
Now it goes on without me, nothing to do
but watch the black shaft turning.

Cactus grows a quarter of an inch
each decade. All afternoon,
mesas pretending to be mountains
bump into clouds that fade.
The only rain all month was rumor.
Like water bugs, antelopes in the distance
wade the mirages. Living on air,

hawks ride out the drought, dipping
and staring. I sit up here and wonder
how many times they can circle,
how many angels dance in a whirlwind,
how many times a bit goes around
before breaking.

The Night of Rattlesnake Chili

Only the lure of a rattler kept us
jerking dry tumbleweeds back
from the bunkhouse. Already, cook had
chili boiling, peppers and beef
convincing us all we were starving.

Cursing, throwing empty bean cans
at our horses, cook swore he'd douse
the fire and dump our dinner to the mules
unless we brought him a long dry tail
of a rattler. I had heard of cooks

crazy enough to grind rattles
like chili powder, a secret poison
to make a pot boil darker than whiskey.
Kicking and calling each other names,
we scoured the range for an hour,

a ranch so cursed with snakes
jackrabbits weren't safe while mating.
At last, I grabbed one by the tail,
the writhing muscle trying to escape
down a burrow, and Billy Ray shot it.

Cook cut off the tail and grinned,
held up the ticking rattle, then
crushed and ground it in his hands.
Hulls floated down into red steam,
and simmered. That night, we ate

thick chili redder than fire
and griped about the dust and hulls,
but begged for seconds. Even our beer
was cold and sweeter than most
and steel spoons melted in our mouths.

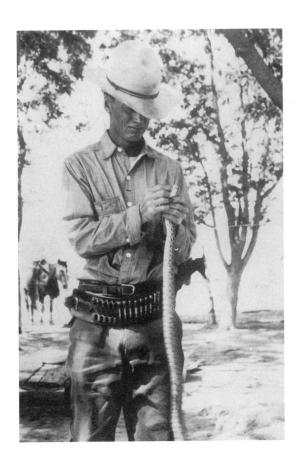

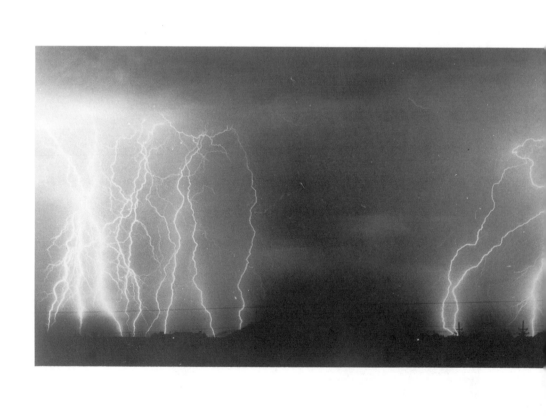

Caught in a Storm on Hardscrabble

Under an oak, I wait out a hailstorm,
caught in a summer day gone dark,
thunder so loud I can't hear myself

yell to the gelding. I'd rather be
back in the bunkhouse, taking my chances
with poker. Isn't my life worth more

than a gelding so spooked he's stomping?
I tug my Stetson and pour holy water
over the dust. The worst thing to do

is crouch under the only tree around,
a lightning rod. I've tried leading this
stubborn fool into rain, but he won't go,

dumber than steers, which go on grazing
afraid of nothing but hunger. I should
hobble the horse, wade out and hunker down

in my poncho. Grass floats on the plains
like seaweed. Coyotes and rattlers
may slink here two by two, the only shelter.

At last, the gelding lowers his head
and eats, believing my lie that we're safe,
that nothing can hurt us.

Tied Up under Trees

Not when the moccasin sidles
between pine branches fanned like ferns,
silent, never moving a needle,

but suddenly, when he drops
half of himself dangling
above the bow of the boat

hanging by a thread of decision,
dark eyes steady six feet away,
pink tongue asking, asking,

my rod tip swinging slowly around
like part of my arm to defend me,
pausing inches away,

broad head pointed at me,
scales ancient as armor,
the eyes bulging, obsidian blisters

which know me now,
and I push the tip closer like a sword
and tap the top of the head

and grab for the rod
lashed from my grip,
the old serpent twisting and falling,

my rod splashing as the snake
strikes the water and sinks,
or swims for shore underwater

or lies waiting in the shadow
of my boat, somewhere dark
where I wait for a while before untying,

without a rod to protect me,
remembering the sight of his falling,
the wide white border of his mouth,
and inside, all tongue and fangs.

The Digs in Escondido Canyon

Last night the Brazos froze. The trucks are here,
bulldozers waiting for the sun. Foremen rise up
for work, fresh coffee all the history they need.
Fish scales glisten through ice like mica.
A dry caliche cutbank shelters Uncle Claude,

something to pitch chips on and worship,
huddled. The pale flames waver like ghosts
of tribes drawn to this stream ten thousand years
before railroad trestles and beef. A million years
to cut a canyon through the plains, forty to pump it dry.

Now, like Moses we walk across the Brazos on dry land.
This fork once watered coyotes and wolves,
bears big as buffalo. He's scraped this dust
for skulls and arrows all his life, uncovered
mammoth tusks and fangs, the pelvic bones of women.

This mud's a genealogy. And now they'd dam it,
hoard this trickle when it thaws, flood miles
of pottery under a lake that's necessary—he knows,
he knows, good water's gold. But they'd bury
natives who worshipped the same tornado skies

we worship. Over his live body: they'll have to pour
their tons of concrete over him, to shut him up,
or tear down his flag and haul him off to jail,
a harmless drudge who means nobody harm, who only means
to dig for bones he might have loved.

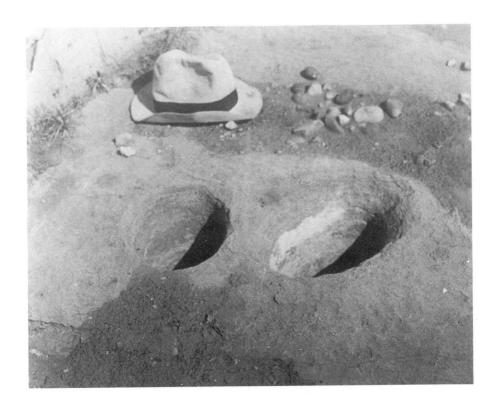

After a Year in Korea

Old Uncle Oscar hated cold, hauled
his lean cattle early into town
to beat the snow. Daddy kept our own steers

corralled till after Christmas,
the winter market hungry for beef.
But Daddy never froze in Korea

like Uncle Oscar's friends, near the Yalu.
I didn't know till later. I thought
Oscar was only a friendly drunk and lazy,

staying inside by his fire, or downtown
at Earl's with honky-tonk women,
sipping draft beer, picking fights

with boys my age with beards
and draft cards they threatened to burn
to provoke him. I didn't know he'd lost

his toes and fingers. I thought he wore
the gloves for show, to make him tough.
He'd end up drunk and humming tunes

with the jukebox, the same old country
and western words he learned
before they sent him overseas to freeze,

a man with two red eyes and stumps,
without a wife, always grumbling in a coat
about a country where they'd done something

awful to the weather, maybe pesticides,
the bomb, good summers short,
the winters hard, more bitter every year.

The Winter before the War

One winter, sledgehammers couldn't break ice
cloudy in the troughs. For days we rode for cattle
frozen where they fell, some huddled by barbed wire,
stumbling in snowdrifts, sheeted with ice

like armor. Sundown, herding survivors home,
we passed a playa lake frozen hard, one whiteface bull
caught in the center. The bull had broken through
up to his horns, his tail raised like a flag,

his head on a platter of ice, wide muzzle stiff
as if he had frozen bawling. That night, we fed
the lucky steers and barred the corral to save them.
At supper, we smoked in the bunkhouse and played poker

and argued how long a bull could have bawled
when the lake gave way. We flipped our cards
and drank and cursed our luck, and tried to ignore
stiff wind and shingles banging overhead.

3

Making Book
on the Aquifer

Driving Home to the Plains

Now it begins, the endless golds
and blues, no forests,
no mountains anywhere.
Sunshine sixteen hours a day,

nothing to shade us, not even
an eclipse. Parched lips seek each other
for escape, the cracked bruising
making blood. Fields this flat

sprawl like the moon,
like Mars. Nothing about the place
resembles home. On land this flat
no wonder people pray, left out all night

like babies that fell off wagons
heading west, weeping all night
for bottles, blankets, nothing ever more
but sky, ten million stars.

Witching On Hardscrabble

Farming on dry land, a man keeps his witch-stick
handy. It might be dark little pepper clouds
at night, maybe a coyote lame in the hip
and desperate, cramming his head
through the chicken wire and choked to death.

Something will give a sign, and faith aside,
you go witching. Women I know like willows,
most men take oak or sycamore. If Zacchaeus
could see the Lord from a sycamore,
my Uncle Murphy used to say, the same branch

ought to point me to the water of life.
But it's maple for me, the peeled crotch
bone-white and hollow in the heartwood,
tiny tubes that sough in the wind like ghosts
I hear offering advice. *Go,*

they moan so low I sometimes think I'm dreaming,
Go. And I go that way for a while, the maple
dragging the other way. I've seen my daddy
bring them in five times a summer. The record
is six, one short of perfect.

I've wondered if it isn't this land I keep
scratching to make a living, hardpan,
ten inches of rain a year, flat
as the day Columbus was born. I've seen wells
brought in elsewhere in Texas. With my own eyes.

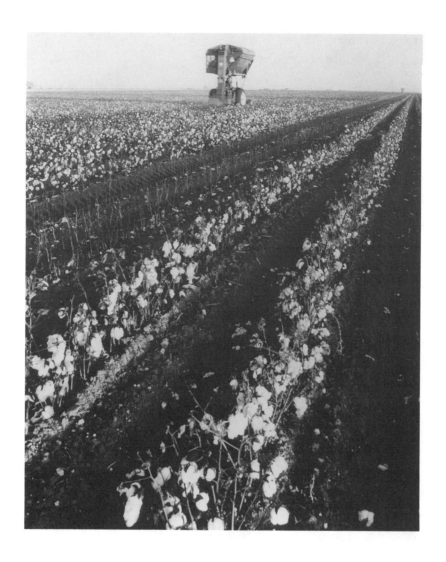

Out of the Whirlwind

Because the land plays out
we're needed.
Nothing in the world feeds us
but dirt. We bury
barrels of iron in sand,

plow magic into farms
dying for nitrogen. We tap
stone pipes in semi-arid zones
and water bumper crops.
After a hail, we squat

among stripped stalks
and shake drenched cotton
in our fists, shake them
at black clouds rumbling east.
Something in the skies

seems foreign, sometimes drought
or sleet, never enough rain
or sun. We believe
given the time
we could reap the moon.

Out of the whirlwinds,
meat. Out of leeched clay,
milk. If we believe
hard work brings wheat
and cattle, we are fed.

Mercy and the Brazos River

My great-greats came to hardscrabble plains
when a dollar an acre was outrage. Quakers
from Iowa, they listened for God's still voice
in sandstorms, a silence under stars.
Patient, they waited for their hearts
to lead them over prairie sprawled flat
around them, a thousand miles of parchment

under the will of heaven. No trees grew native,
only buffalo grass tall enough to hold the bones
of slaughtered buffalo. If they hoped for angels
to wrestle for crops in the desert, when they found
this winding Texas stream, *Rio de los Brazos
del Dios*, they believed. Now, that canyon's

drained after decades of irrigation,
near a city of a quarter million
which pumps its gyppy water from a lake
a hundred miles away. In 1880, the dugout
where they huddled all winter was a tent
half buried in walls of white caliche. In spite
of rattlesnakes and drought, they called it home.

The holes of prairie dogs pocked every acre.
Even the home they dug uprooted a colony of dogs.
They plugged the burrows and settled down
to stay, enough grass like pastures of heaven
for cows which survived the blizzards.
I've seen the grainy photographs, held in my hands
their beaten plows, the cracked hames of horses.

How could they leave their families for this?
What did they hope for, choking down rabbits
and snakes, enduring wind from wide horizons
without one tree, nothing but hawks in the sky
and slow whirlpools of buzzards? I've heard
the first deep well they dug was hopeless,
every dry foot like stone, and the second.

Before the third well struck an aquifer
at last, they turned enough prairie under
for a crop and a baby's grave, their plow
silver-shiny, their wagon broken often
but repaired in time to bump down that steep
caliche canyon and haul back barrels of water
from the river of the arms of God.

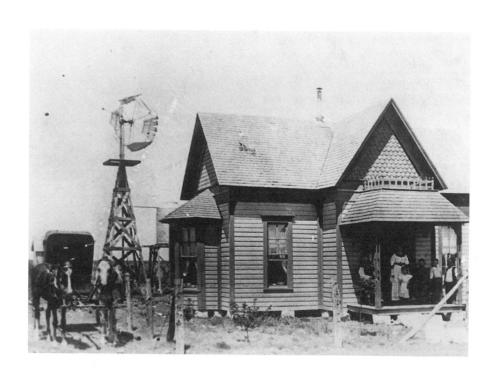

Settling the Plains

For here and for the afterlife
they worked and sang, kept time
with hymn books in both hands,
old songs of God's good grace

in a land so dry they planted
cottonseed to prove they believed
in miracles. They buried their dead
on plains with no native stones,

deep in the earth to save them
from sandstorms that pounded
daily from the west. They prayed
for rain, the sun so dry for months

they couldn't curse. Rain fell
in floods like manna twice a year.
They lived on daily bread
 and called on God to bless them all

for doubting. They believed
whatever they put in the dirt
would live, if it was God's will
and the wind blew.

My Brother in Summer

Here on the Texas plains he wakes at five
whether there is work or not.

I used to wonder, what is there to see
when even the sun rises after him,

and then nothing but thousands of flat acres
of only green encircling his house, each field

always the same as his. In the morning twilight
he stoops and feels the dirt in nearest rows,

sips his coffee and in the silence
hears the cotton grow, each of a million

leaves at work, sighing oxygen,
pushing itself toward its own white death.

Seining for Carp

The carp keep coming back, no matter how many
times we seine the pond, the lake no bigger
than a bathtub, we joke with friends
over for the weekend. Trying to fish away
whatever brought us here, we cast our
bread upon the water for bass or bluegills
and the hooks come back bent with carp,
carp fat with bones like wire mesh, nothing

worth eating, ugly, scaly, leeched-out heirs
of five-and-dime goldfish my daughters
freed one summer. Putting aside our rods
and lures, we scuba dive ten feet down,
searching the bottom of this hardpan
playa lake, the water clear as a lagoon
and barely cool. Later, lying on the warped
pine pier, smelling the burgers sizzling,

we dream of trout white to the bone,
the bones lifting easily, the taste of aspens.
The last thing we need today is carp.
Where they hide must be in fissures of stone
or shadows of our heels as we swim by.
Trying again, four of us unfold the minnow
seine weighted with sinkers, bite down
on oxygen like hooks, and let the long net

reel us along the bottom. Even down here
the shadows are dawn, too light to hide more
than minnows. But feeling along like warlocks
scraping the bottom for newts and owl eyes,
anything to cancel the spell over us
all week, we drag the seine behind us,
waving our flippers at carp with all the time
in the world, watching us go by like minute hands.

It doesn't take an hour to make the sweep
and start the hard haul up to sunlight.
The first one up kicks off his flippers,
digs in and pulls us in like climbers
dangling down the sheer face of a cliff
we have struggled up for days. Then one by one
we surface and tug the net to shore like a barge,
the water heavier this time, it seems, with all

the fish in the sea, the net hissing ashore,
flouncing, hundreds of minnows, a twig
black as a water moccasin, a few snarling catfish
the size of thumbs, a dozen crappie, and carp,
a single carp, not even flipping. We could have
saved the trouble, the dead carp not even fit
for the cats. Quickly we launch the net
like an ark and save them all, then flounce the net

to rinse it, and close together, folding,
feeling the plain week ahead close over us, wishing
for someone to come walking over the waters
of our lives and tell us, though we have fished
all week and taken nothing, to let down there, down
there, where the water is clearest, where the secret
carp wait in the open, catchable, all the carp
in our lives easy to seine and toss to the cats.

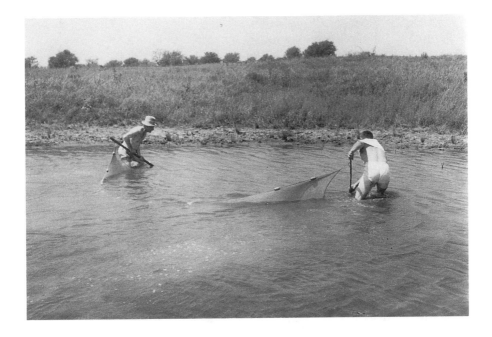

Mounds at Estacado

Hawks alone could have loved it
before pumps and irrigation,
horizons of cactus. Wolves caught rabbits
stampeded by buffalo, miles between water holes.

Grandfather rode a bouncing wagon here,
his wife worn out by Amarillo, five children
squalling for meat, for water. He fed them
rabbits and prairie dogs. My daddy said the meat

was stringy, needing no salt. The last buffalo
was penned at Jake Smith's trading post.
Granddaddy pitched a tent which blew away,
West Texas sandstorms worse than Iowa winters,

ashes from heaven. He buried his wife that year
and took a Quaker maiden from Estacado.
She bore him four more boys and buried him
herself in Estacado, the only Quaker left.

All others rolled their wagons to the Gulf,
even her parents. I've seen some cousins
in Galveston, held in my hand their hands.
They watched me as if I were the ghost,

survivor of sandstorms they carry as folk tales,
one great crazy aunt who stayed on the plains
like Lot's wife. I've touched the stone she turned to
on Granddaddy's plot in Estacado,

a graveyard bordered by barbed wires,
ghost town surrounded by pastures,
cows and romping calves in all directions,
bumblebees roaming the miles of cactus.

The Eyes in Grandfather's Oils

Wolves again. Grandfather roamed these fields
on horseback, half the time drunk,
before he turned to oil and preaching.
Landlords in Scotland paid him to save their steers
from wolves and renegades, the only water
in dry caliche creeks or scum-green in windmill ponds.

He shot to save the calves. He didn't say
how many wolves or men he killed. How many
did he really see, or was it the Scotch
they paid him? His first painting's dated
before he rode the circuit to Amarillo,
a Baptist preacher who dunked green hundreds

in those ponds. He said he painted what he saw,
that's all—yucca and scrub mesquite,
dark arcs in pale blue skies, horses and hawks,
anonymous friends named Bill or Charlie,
steers of the herd and bones of buffalo.
Often in these oils, wolves watch him

almost out of sight, crouched behind cactus
as if hiding from rifles, or coyotes loping along,
keeping up with the herd, or seen suddenly
in moonlight through a bunkhouse window,
their eyes staring through the canvas
glazed by oils and starving.

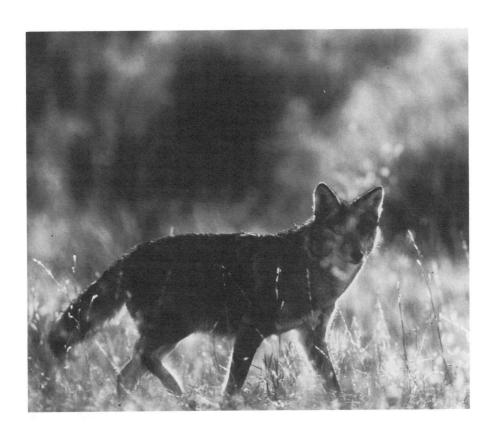

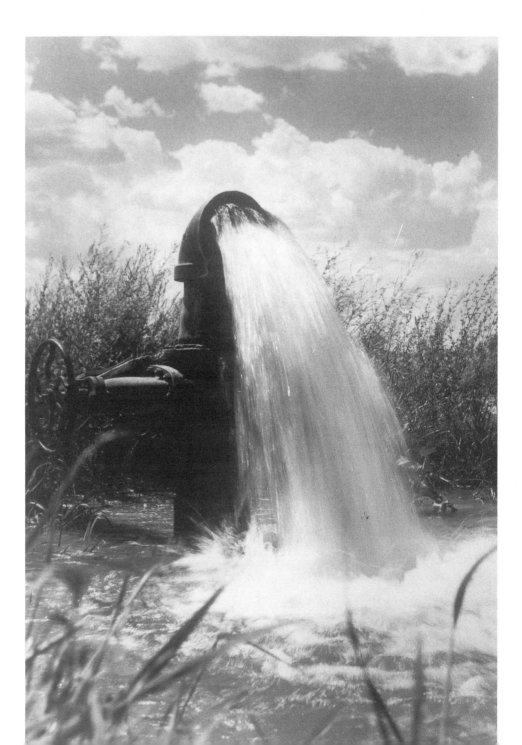

Drying Up

Anytime from March through fall
you can hear somewhere on the South Plains
engines like mosquitoes sucking the purest
water a hundred, three hundred feet
up to the surface, irrigating
this plowed land into life.

Nights as a boy I would lie in the furrows
waiting for water to soak its slow way
down the rows, the smell of only earth
and cotton leaves easy to breathe in acres
of oxygen, the breeze now and then blowing

the news of water on its way, the moist smell
of dirt dying to mud, millions of acres
living on nothing but transfusions from beneath.
Now, stretching through hundreds of miles
of sand aquifers squeezed like sponges,
the Ogallala water table drops

three feet each season. Pipes of the wells
go deep, and some dry up. Sections of land
go back each year to sand and blow away.
My brother with no choice changes oil in his engines,
tightens the nuts and in March starts them up
again. He waits. The wells suck deep. The water flows.

Dust Devils

Here is where heaven starts,
wind like the spirit of peace

blowing sand in our eyes
for weeks. Spring on the plains

is a month of static and storms
without clouds, the blustery days

dry as fields fallow all winter,
the sand like our own souls

naked, harrowed and seedless,
waiting to be given wings.

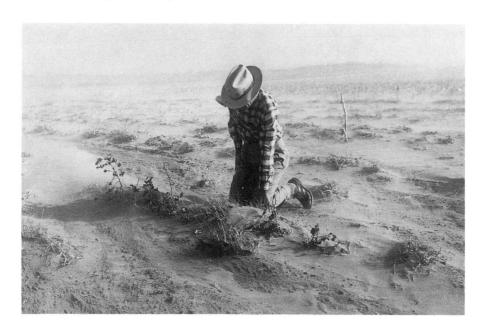

Blue Skies

1

Under the crisp reeds
mud smooth as leather
dries out, cracks
and curves up into hooks.
Frogs caught in the drought
leap between points,
the hot sun drying their
legs like jerky.
Gathering themselves
they leap, believing in
clouds, their throats
bruised puff by puff,
the soft dust
drowning them.

2

At last light the pond
holds heat waves
deeper than glistening water.
Mourning doves
frantic for light
flatter the dust
by dropping down
as if to walk on water,
glide up,
circle,
and dart away,

dipping and diving
the way they flee light
glinting on shotguns.

3

On a cliff,
dapper in moonlight
on thin legs
and four splayed feet like spats,
a coyote with his heart
on his tongue
sniffs, sips a puddle
of air. Nothing.
A breath of wind
would be enough,
odor of coney, possum,
raccoon with ringed eyes
and sticky fur.
Even a turtle. Anything.

4

Better this than rain,
these cool nights clear,
the grit of dirt and dry stones
giving firm purchase to all
scales of the belly,
the leeched earth perfect
for shedding skin, the long
muscle of a back undulating,
beginning to glisten

with diamonds emerging
in the cool moonlight, the fangs
ready, the rattle tip-up and poised,
the tongue never so dry as now,
flicking, flicking, able to taste
the thinnest aroma
the wind will bring tonight,
the wind like a god
always present, whether still
or moving, the wind knowing,
the wind always delivering.

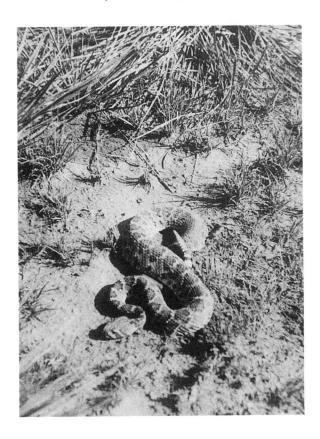

Sundown

He's not alone, the old bull
hump shouldered by the barn.
Scars like braided whips on his back
pucker in the cold, like other bulls

backing off. He snorts,
and flicks his tail.
Night coming on,
he has walked stiff legged

and swaying to his stall,
no longer tossing his horns,
no longer expecting one of his herd
to be there waiting, her narrow back

and barrel turned toward him,
quivering. Always a trough of grain
is there in the shade,
and he goes for it now without desire,

without fighting the pain in his nose,
the ring long a part of him
like the cramp in his legs
he takes with him everywhere.

Eyes glazed, he lowers his head
and eats, blowing the dust,
the hulls. Finished with all that
at last, he waits

on four legs in the dark
and listens to his farm, the last hens
clucking, the snort of horses
in the barn, the faint

swishing of cows' tails,
and somewhere far off
a dog's persistent barking.
He closes his eyes,

leans a degree for balance
and feels the barn,
the weight of the farm
and the long day disappear.

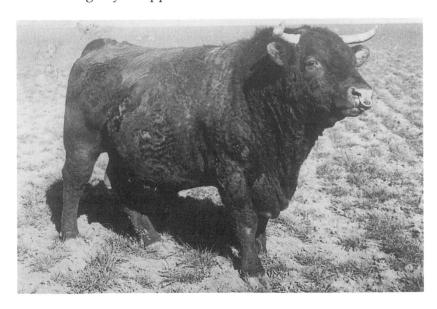

A Brief, Familiar Story of Winter

The barn is telling the story of winter.
The calves are trembling. They love
a new story. The horned owl blinks
and tries to sleep. He has heard it all
before, like field mice squealing head down
and flying for the first and only time
of their lives.

This summer's hay lies still, feeling again
the slice of the blades in harvest,
the long strange nights afterwards
in moonlight before they loaded and hauled it
away on trailers bumping to the barn.

The doors are open as wide as they can go.
They know when the barn is done
with fiction, someone will come
and shut them in and snow will fall so tight
some won't be opened until spring.

The pigs outside the barn are grunting
and squealing. Like the doors, they don't
want to hear about it. Especially not
this part, the story of the first deep
frost, white grass, white leaves, even the mud
crunching under their hooves like bones,
the same sharp slicing sound of knives
stropping together, the soft click
of a rifle bolt opening and sliding

a bullet into the breech. The pigs
can't stand it, they cram their snouts down
deeper in the swill and eat and eat,
every last one of them.

The calves are chewing their cud
and listening, like good children.
They believe it's only a story.

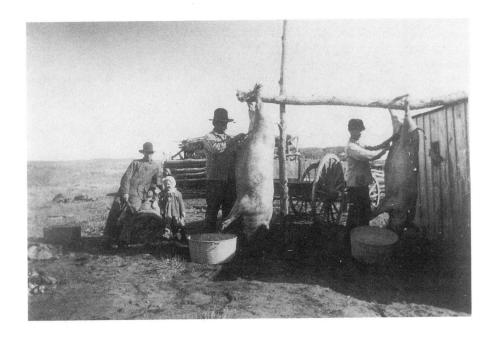

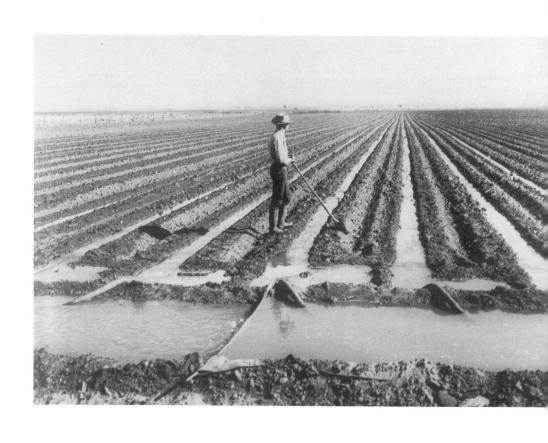

Making Book on the Aquifer

When it doesn't rain, we water,
pumping the purest water three hundred feet
straight up from nothing we've ever seen,
raising bumper crops by faith alone.

If we didn't know the world is dying,
the Ogallala water table dropping
three feet every year, we'd swear this water
would gush forever, like Aaron's rod that budded

without touching dirt. Even in snow
we sit in firelight and watch our fields
fill up, stranded these dark evenings between towns
and miles from mountains, but knowing

wherever others on the road a mile away
are going, we are here.

4

Tornado Alley

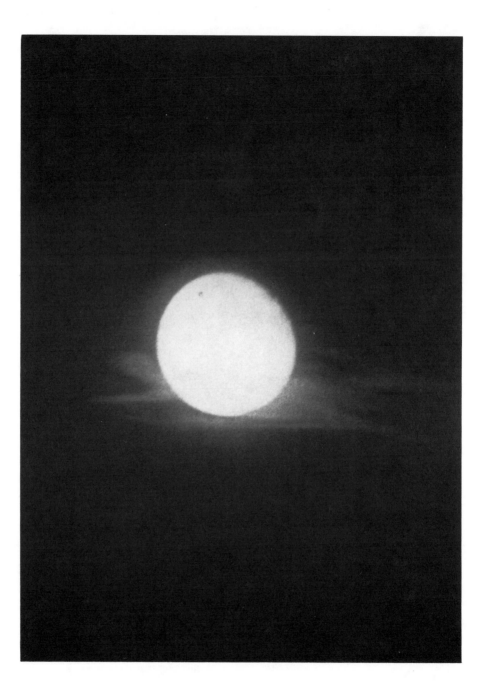

At the Football Stadium

Last night, beyond the flooding
stadium lights, up through a cloud deck
in a sky too dark to see,

the moon emerged, a round orange tunnel
in the east. My son, his oval eyes
responding, reached for the case,

squeezed black binoculars together,
focused the night
through dark scoops of space.

Silent, under the savage crowd noise,
beneath the lenses and his fists
he mouthed an O.

Marriage

The neighbors' dogs have howled at the last
siren and gone back to sleep.

The lights of the park switched off at midnight,
a dark garden of swings and fountains.

I hear jet-roar
far away like a waterfall.

This late at night she returns
with slow breaths, bearing vines

of the darkest grapes,
pomegranates which open soft as lips.

She knows my eyes are open
and kisses them shut so I can see.

Her fingers know the dark
corners of my mind,

her mouth repeats the mysteries,
her flesh becomes flesh.

Animals trot by outside our window
for the blessing of names.

A Woman Acquainted with the Night

My wife is not afraid of dark.
She uses lights like handholds,
climbing down caverns she accepts as found.
She is as comfortable as blossoms

when the sun goes down.
Forests we've camped in at night
are forests, to her, clear eyed,
seeing no visions she can't

blink away. In sudden dark,
she goes on mending clothes by feel
while I sweat and rage
to make the spare fuse fit.

When she was six a fat man
digging a storm cellar
shut her and a friend inside,
stood on the black steel door

and stomped like thunder.
Frozen, too frightened to reach
for Becky screaming in her ears,
she felt nothing could ever

be that dark again. In time
the door clanged open and light
baptized her with perhaps
too deep a trust in saviors.

She lies down now in darkness
with no human hand but mine
to cling to, nothing but faith
in the moment to let her sleep.

When storms short out
the relay stations, she knows
how to touch me, how to make
romance of failure,

knows like blind friends
how many steps to the candles
so if our children wake and cry
for light, there will be light.

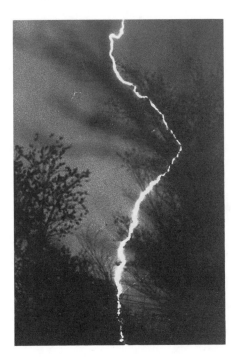

Praise

Under the threat of summer, trees
bring forth their fruit, here in a zone

so dry no trees grow native. The last
late killing frost was years ago.

We're overdue. Thousands of robins
dip down and believe it's spring,

listening to the tongues of sparrows
which seem to sing, bland little birds

that never go anywhere all winter,
and somehow survive.

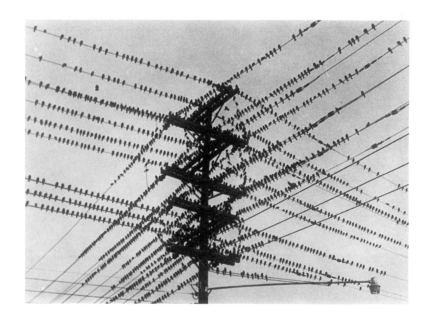

Prairie Dogs Live in Lubbock

except a few hundred in colonies
near towns like Muleshoe, Midland,
and Littlefield. All others
have disappeared, starved by farmers,

poisoned, wiped out in thousands
by the plague that rides from colony
to colony like royalty
in the cushioned stomachs of fleas.

Ranchers hate varmints, losing good mounts,
forelegs snapped by their holes. Once,
boys could stand a mile out of town
and shoot at dogs with .22s all day.

Now, the city's Prairie Dog Town
has a wall and a law against molesting
the hundred rodents which scamper
like rabbits, stand on hind legs

and try to bark, and the dozen or so
owls that squat like ceramics.
Young couples bring their children
to feed prairie dogs once or twice

over the years. And sometimes
in the cool of evening, old people
driving slow will idle by the fence
and watch them bark awhile.

Where the Trees Go

In time they all rise up
and walk away. For years
they lie where they fall,
leaves brittle, branches

twisted like fists. In time,
even the bleeding stops,
the stumps seared dry by snow.
The others learn to go on

without them.
They watch the wings
they were always too near
to notice, from learning to fly

to flying. The birds
seem never to die. They fly
away, they simply
fly away. The trees lie still.

Silent for years,
they dream of leaves, of wood dust
light as feathers. They dream
they pick up their beds

and walk away. They have found
where the birds go. In time
the other trees look down
and find them missing.

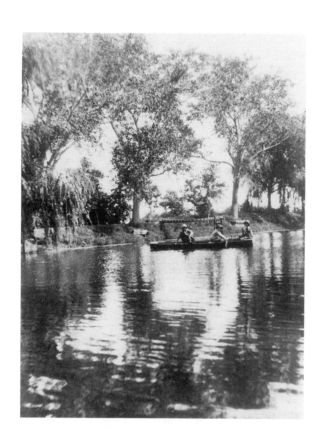

Old Men Fishing at Brownwood

Spitting tobacco juice on hooks,
we skewer silver minnows that writhe
in the light of the moon, lining our boat
with bass fighting for all the line

they're worth. These are the shallows,
the home of the moccasins, deep mud
of the turtles. Our flat boat wallows,
bumps over stumps, and stalls. Slowly,

slapping mosquitoes, we pole it off
and glide in moonlight between branches
like scarecrows. What we desire
winnows the dark under logs

flooded for years, in tunnels of reeds,
deep pools in the shallows. We believe
we will know what we need when we find it,
though it may take nights on still water,

for we are too old to turn back, to settle
for perch in the daylight, willing to risk
pneumonia or stroke, the hiss of fangs
nearby on a shimmer of water.

Setting Out Oaks in Winter

No trees stay green all summer here,
heat stressed, blighted,
full of drought. Nothing thrives
by itself without climate
I can't promise—wind gusts within reason,

more rain than falls, enough birds
to eat the leaf lice. The wind
is foreign, and even with silver iodide
and prayer, it rains only when it rains.
Birds fly over every year, a desert

between snow and tropics. We breed our own
with baths and feeders in the yard
high off the ground above the dogs.
In winter, since dry land never freezes,
we dig through sand to white caliche

and throw in loam like pennies, lift
bought trees balled up in burlap
and swing them overboard like treasure.
The only way these trees survive
is like love, anchored to posts

in the ground like blessings
against the winds, pruning
what isn't required, soaking them
over and over with water
pumped from our own deep wells.

Losing a Boat on the Brazos

Downriver rocks were rapids. Believe me,
even fish have ears. Sweating, we coasted
too far out on a river we've fished
for forty years. I swear it's never
been this low, but two old cousins
can't keep the Brazos full forever.

Sharp rocks are death to aluminum boats
harder to split than wood. We're safe,
spitting out mud and minnows, but alive
after months of drought and a soaking.
Bury the boat and forget it.
We could have drowned any wet year

under tons of the Brazos flooding
downhill to the dam. We could be food
for alligator gar and catfish.
That rip is wider than the lies
we'll tell for months, the size of bass
that got away, the granddaddy cat

we finally caught that flipped
and disappeared through the hole
of the boat, going down. Let's sit
on the bank and laugh at why we let
eight hundred dollars of rods and tackle
sink and saved a shell worth less

than beer cans we crush for salvage
every day, two old fools splashing ashore,
dragging a gashed boat out
as if dry land could save it,
like old bones mired in mud we've proved
can rise and walk again.

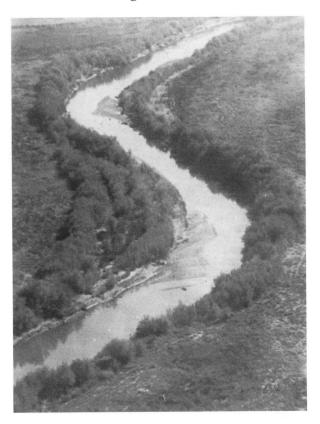

Tornado Chasing

At night the CB crackles
and I back out. Hail pounds the pickup.
I drive for hours under blurred lightning
on highways. Now I can find it,

if it's here. In twenty years I've seen
a thousand twisters. Most nights, I'm the fool
they think I am, risking my life
for nothing. But they listen like prayer

for my eyewitness news, and they believe.
Bouncing down dirt roads, I call
Tornado sighted and chase the devil's
tongue until the road dead-ends

or the thunder dies. They know the force
I follow, the vacuum of black funnels
in flashes. They gasp like me
and breathe the name of God.

Night Missions

Tonight will be like any other night.
At two or three the phone will ring
soon as I've drawn the first good hand.
I'll spread the cards face up,
knowing solitaire won't peek. Pecos,
Abilene, it could be anywhere
south of Denver, someone badly burned,
skull crushed like a hard-boiled egg,
needing a surgeon in the Southwest
who could put him together again.

I fire up number one, then two, propellers
spinning so smooth the Cessna shudders
until I release the brakes. I taxi out,
in the red glow of the cockpit
I run the checklist, flip on collision lights
and find all gauges in the green.
I hit the runway, fire-wall both throttles
and line up on the roll.
Banking, I'll clip the moonlight,
blue wings climbing somebody's dreams,
tuned blades humming like mercy.

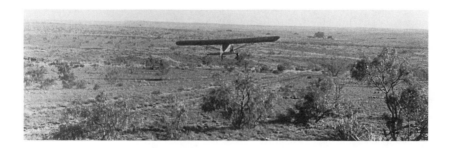

The Children's Hour

Let's try spinning autumn into gold.
If straw spun for Rumpelstiltzkin,
leaves already bronze may blaze.
Our rakes go back, go back under shrubs,
over roots, combing the lawn like yarn.

The neighbors' mockingbird
twitters and clucks in the sweet gum,
flashing its tail and teasing.
Pile after pile, we heap up leaves,
wishing the wind would wait,

chasing them with our rakes
like loose coins rolling toward the curb.
Late afternoon, yard combed,
rakes put away, three shiny black bags
bulge with money, if time is money.

We heave them into the dumpster,
hiding our hoard with others' trash.
Years back, we raked loose leaves
and let our children splash, tossing leaves
like money, then called them to help rebuild

a castle of leaves, and touched a match.
Flames the color of gold leaped up
and changed dry leaves to fire
brighter than the sun going down,
all of us shielding our eyes and silent.

Deductions from the Laws of Motion

The countryside is quiet, except that contrail
going somewhere in a hurry. Soon
we'll hear the sound, only a far-off roar.
It's like trying to hold water
in your hands, here where rain

is the name of luck. We came here
mainly on a dare, hoping the war was over.
Our cattle wander fields in a shimmering mirage.
Even in winter they feast,
bundles of feed brought to them,

browsing on sticky alfalfa saved in a silo.
Deep wells dry up, plains where nothing
comes easy. Beyond the weedy playa lake
where ring-necked pheasants mate, rattlesnakes
rule the cactus. We never find plains rabbits

dead of age. Oh hawk, make up your mind,
dive and take whatever you're after now.
Barbed wires strung up on nails can't tame
hard blizzards storming down from Canada.
Our dogs stay warm in the barn all winter,

even if late freeze kills blossoms
without mercy. In spring the wind shifts,
restless as river mud. Nothing not tied down
can resist stiff winds. Sandstorms shove
and push but never bend the roof.

In spring when tumbleweeds stack tight
against the walls, we stuff wet towels to jambs
and window cracks. Splattering sand beats
pit holes in the glass. How did they know,
the old ones, which tornado sky to worship?

All roads lead away from here. Today
I found another tow sack in the field,
kittens someone in the city believed I need
for fertilizer. I loosed the knot and dumped them
in the barn. They'll live on mice for months

until one by one they leave. Cats on the farm
never need for long what we offer, proof
they're not alone, here with wide horizons
to amaze us all, always on the go
over miles of sand under a spinning moon.

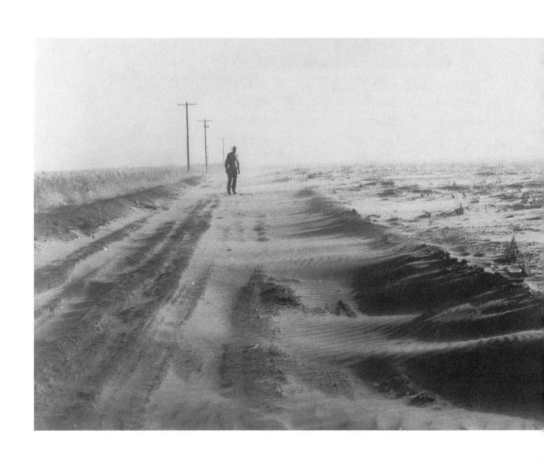

Sandstorms

How many nights can we take it,
the constant blither of wind,
the splatting of sand

on the windows? We would pray
for rain, even floods, here
where nothing comes of all our

tossing and turning, trying
to sleep, but dust in the morning
to whisk away with oilcloths.

Nothing can keep it out,
not locks, not wet towels
plastered to the cracks. Dust

floats through every room.
Even our feet as we tiptoe
tap up a plume,

a soft tattoo of dust that follows
everywhere, an echo of outside
weather. We wash sheets

twice a week and slip between
clean percale already grainy,
our bodies rubbing away to dust.

Living on Open Plains

We thought we knew these flat,
flat miles by heart, mileage counters
inside us like circadian clocks.

Born to the plains, we learned landmarks
like the hollows of each other's flesh.
We gauged the wind by how deep

sand could drift, the depth of drought
by how many coyotes howled
on the horizon. Now,

four parents buried one by one,
the landscape shifts. Our children
grow away from us. This one

takes the stars, this one, the wind.
They live in cities
without flat horizons.

How does the sun set there?
Where are the coyotes, now?
Where is the sand running to?

Alone in a Windstorm

These are the fallen apples,
the proof of wind, the roots' labors.
All night in the storm
we lay touching, alone at last,

our children scattered
this autumn weekend.
The dogs stumble
as our rakes go back, go back

under the cracked branches.
We rake up apples like winnings
and count our losses by the bushel.
We touch the hail-stripped limbs

and sever all we must.
After rain and raking, the grass
is greener than we've ever noticed.
All afternoon we're sleepy,

fatigue that saves us
for another night, no matter
how hard the hot wind blows
or if the whole crop falls.

5

Weeds, Barn Owls, All Nibbling Goats

The Goats of Summer

The clink of steel diggers rammed
on sandstone makes pet goats easy to despise.
Without a fence, they'd baa and billy leap
wet fields of oats or cotton, nothing sacred

to their hooves and nibbling lips.
Leaning the diggers in a hole of stubborn rock,
I wipe a wet bandana on my face
and sling my Stetson like a watering can.

Standing still at noon, I feel my boot soles burn.
What madness made me believe the silly song
of barkers selling goats, kids for kids,
the catchy phrase erasing the smell

of pellets, the wide-eyed grin of baby goats
and children tugging my sleeve
more whimsy than a man could stand.
So now, days later, where are they,

those knee-high babies nudging for bottles?
What are these hip-high goats with deep voices,
butting the backyard gate until it warps?
Where are my kids who promised to clean

the daily straw reeking like Noah's privy?
Tugging old leather gloves back on,
pliable with sweat like second skin,
I lift the double blades and drive them down

like breaking teeth, squeeze out the broken stone
and go on digging, rolls of barbed wire
waiting to be strung, a dozen more dry holes
before there'll be some order to this dirt.

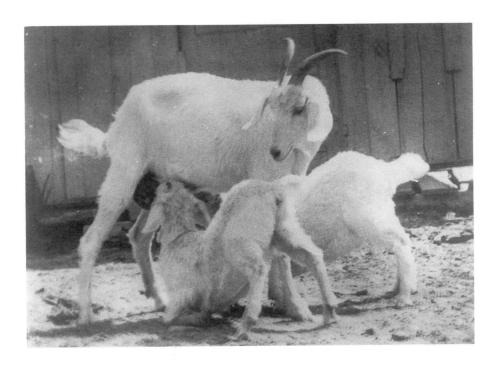

Building on Hardscrabble

Chopping down dense mesquites
was not enough. Every other step
was cactus, eighty flat acres
and a lake lapping one corner.

Kodachrome brochures
lured us miles from plumbing,
blinded by sand our first night in,
hub deep and stranded.

Under the stars, the only sound
was buzzing, mosquitoes all night,
gas from a dammed-up lake,
a hint of skunk.

All summer, hawks glide and sidle
in vacant skies.
We sneeze bleached
yucca blossoms, hammer

and saw on hardscrabble
fit for goats. At night
the splash and battle of bass
in the shore reeds,

nothing outside our windows
but snakes making the rounds,
holding their rattles
tip up and silent.

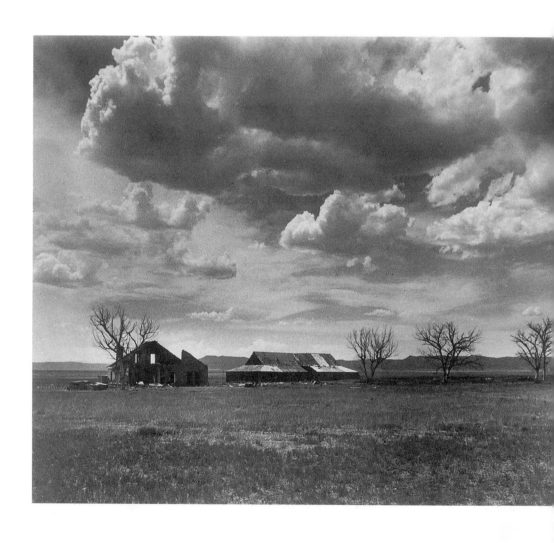

The Barn on the Farm We're Buying

We slide the barn door wide and cough. Dust swarms,
the half-buried droppings of horses and owls
like feather dusters uncleaned for decades.
The rattle of rollers echoes in the barn,
abandoned to straw never changed. Hames of horses

creak when we lift them. Our flashlights
sweep past empty stalls. Dust floats
from every beam, embalming all but us.
Not even a barn owl stares, digesting
last night's mice. We tap the walls,

the sturdy posts. Why do we talk hardly above
a whisper, when no one's close enough to hear
and we hold the deed? Did he care
strangers would buy his barn
when he and his horses were gone?

Where are the rotten planks
we'd counted on, the cracked rafters,
the sagging roof? How can we tear down walls
he built to last? Where are the layers
of gauze cobwebs we thought would serve

as kindling? On these dry plains,
can't even spiders live? Nothing in the barn
seems old but leather, and dust
we're growing used to, our other odor,
the earth we're beginning to call home.

On a Screened Porch in the Country

We scan the sky for jets whose radios are dead.
Out here, no one but peddlers call. They'd gladly
buy our crops for talk. Mirages flood the fields,
a shimmering lake ablaze. Our cattle

wade to flat horizons and never drown.
Sundown, we sink into the porch like an ocean,
rocking like treading water. This scorched earth
is rich with the bones of buffalo, gone

before we bought it. The road's a market for buzzards
perched on the barbed wire. Often at noon we see them
overhead, gliding for something beyond salvation.
The sun dies spangled in clouds of another county.

A neighbor's dog barks at darkness. Our old dog listens,
then takes a turn around the yard, all of it his
for the moment. When tires whine by on the highway,
we know the meaning of alone. We live on sand,

after the madness of Saigon. Was it worth it
to sign a deed like a separate peace? Coyotes howl
because their world is moonlight. Tomorrow's weather
forecasts hail, the first squall of tornado season.

I swore I'd work these rows and never look back,
as if blind faith could save us from nightmares
stranded in Saigon, trying to fly home. Now,
between wars, I know that everything needs mercy,

even that jet above us, roaring somewhere by faith,
in radio contact with all controllers they can find.
We leave the porch light off and rock in darkness,
watching wild eyes flashing in the fields.

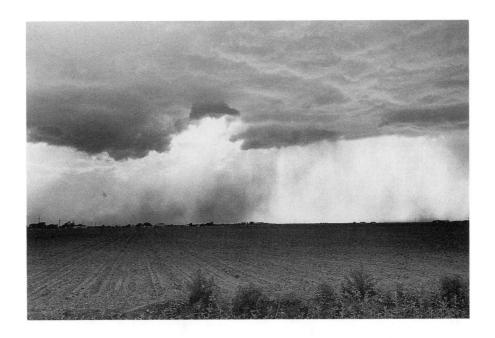

Finding My Father's Hands in Mid-life

What enters my hand is stiff
and cold, like old leather,
rough like the hide of a bull.

So this is the fist
of my father, the fist
he struck me with, the claw

my hand turns into. Even the nails
are his, brittle and thick, beveled
when I hold them under light.

Broad fingers, puffed at the joints,
knuckles of both fists buckled,
crisscrossed with lines like scars.

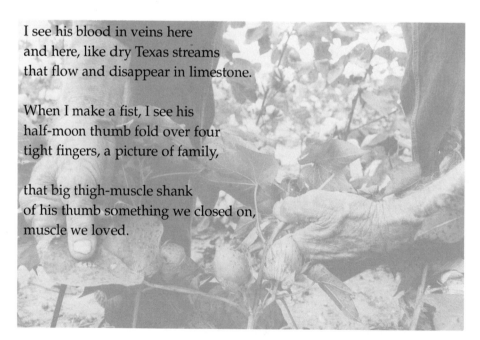

I see his blood in veins here
and here, like dry Texas streams
that flow and disappear in limestone.

When I make a fist, I see his
half-moon thumb fold over four
tight fingers, a picture of family,

that big thigh-muscle shank
of his thumb something we closed on,
muscle we loved.

Things about to Disappear

Pronghorns the size of fawns
dip down and drink. There's no more water
for twenty miles, the next shallow canyon
on the plains. If they sense buffalo bones

diggers find each summer, thirst muzzles them.
They stare, antelopes on thin stick legs,
faster than a horse can run. From the car,
we count two dozen, holding field glasses

steady as we can in cold wind gusting
from the north. Thousands of ducks fly over,
doves, geese in arrow formations, pointing the way
away. A car backfires, or a rifle. Startled,

antelopes bolt up to high ground, the plains
surveyed and settled. They gallop away,
they never pause, before our eyes they fade
like a legend and run for miles.

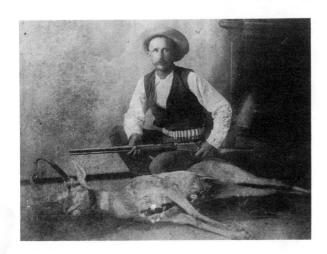

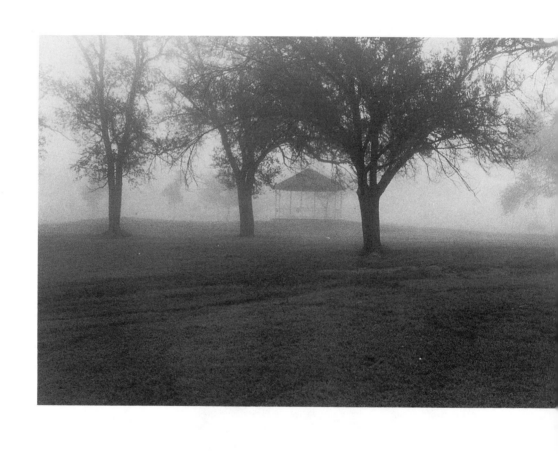

Whatever Ground We Walk On

We walk until the moon rises
to meet us like a lesser goddess,
orange and bold as the sun
seen through dark lenses.
And the poses it takes, all that
posturing behind willows,
veils that make it thinner,
then sulking into clouds
like a movie star to be alone.

Seen from the moon
where nothing is orange,
this field where we are
under clouds is white
swirling around a rich blue
planet, the proper place
for summer shirt-sleeve walking.

Years ago who dreamed we would
waste the moon just walking?
Near is a house we could enter
in private. Once we thought
we could not breathe without it.
Yet here we are, not even touching
and the moon is up, and rushing.

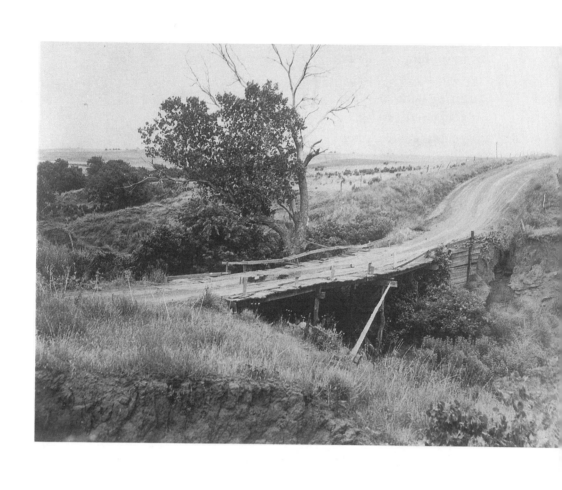

Plains and the Art of Writing

A prairie lays its mystery face up
on the plains, nowhere to hide
from black, spiraling mobiles
in the sky, the sun a bully
breeding hawks and buzzards,
no shade worth claiming,
at night the moon, all-seeing eye
blessing barn owls floating
soft feathered over the earth,
without a sound.
I love this cactus land,

the way it all says wait,
the moon a headstone
worshipped all night by coyotes
seeking the highest knoll,
praised by rattlesnakes
excited by the scent of blood
stirring at dusk,
slowly uncoiling,
tongues flick-flicking,
long muscles flowing
over the old, familiar sand.

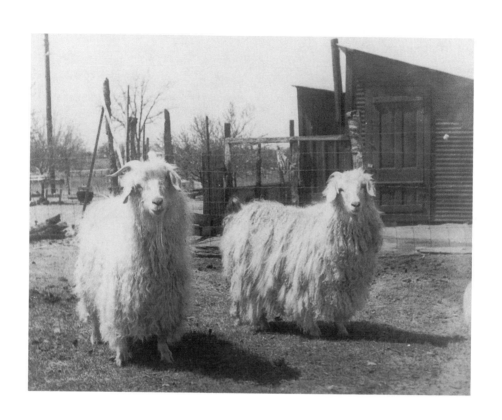

Goat Ranching

I could let go and live with the goats
that forage our mesquite and cactus,
browsing on grass, salt blocks

and cardboard boxes that tumble up,
and saunter to the tank to drink.
They've never killed a kid by kindness

or neglect, never had to put their kids'
old dogs to sleep, friends
that drool and quiver and stumble

hobbling to our hands. I've never
seen a goat afraid of trouble. Horny,
they strip the bark off cedar posts

and stand for hours in moonlight,
whetting their horns like sabers
on barbed wires.

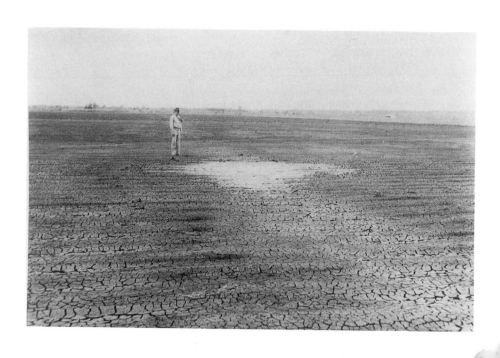

Weeds, Barn Owls, All Nibbling Goats

We chop these weeds with hoes filed shiny.
Nothing but rain could save these puny roots.
Enough of killing weeds for a hobby. Wrong,
maybe, trying to make blown sand
say beans as well as grass, the nearest lake

a hundred miles away. Bless weeds
that wring hard water from this dirt.
We'll throw the gate wide open
and let goats graze until they bloat.
Even a stunted pasture feeds them.

The days of miracles may not be gone.
Too old to start over, we watch for signs,
a front, a steady shower. An inch
would yield Kentucky Wonder beans to freeze.
Neighbors could pick their fill.

Even that dried-up playa lake
could be a pond. We could breed ducks
imported from swamps, bees and gazelles.
Afternoons, we rock together,
sipping iced tea from depression glass,

watching mirages for a hawk,
the shimmer of heat waves breeding
whirlwinds, but no angels in the clouds,
sometimes an owl blinded by sunlight,
weaving from barn to barn.

Leaving the Middle Years

Slow blues beckon us to move,
the sawdust dance floor almost deserted.
Sunday morning fog won't settle outside
for hours, though it has already here,

lazy smoke layered like haze
in the mellow glow of the jukebox.
We wonder where our children are tonight,
flung wide from coast to coast,

old enough to choose their own
curfew and music. We miss them
and their own sweet babies
growing fast as these wax records

spinning on a vintage burly Wurlitzer
not even as old as us. Come,
let's join sad others on the dance floor
before it closes, the whine and glide

of fiddles and steel guitars
sentimental enough for lovers bound
by more than rings and wrinkles
deeper than any scars.

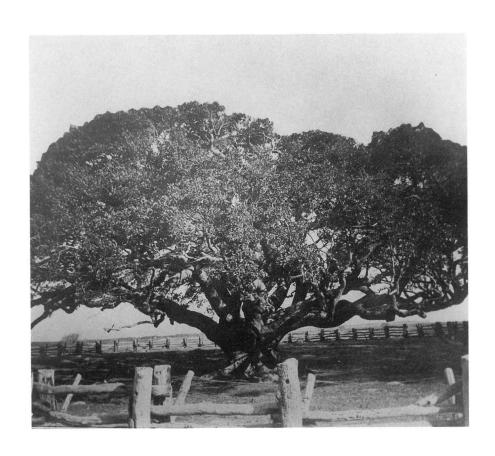

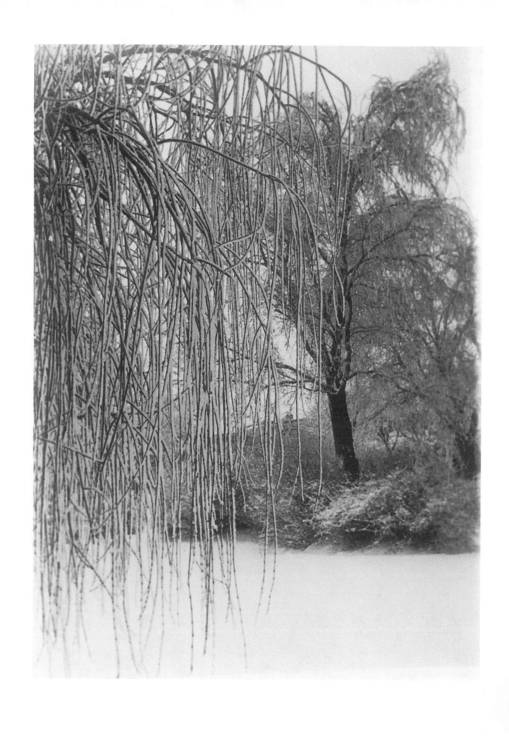

Rock Softly in My Arms

Forget the bells, the call to order
in assembly. High school is over,
boot camp a snipe hunt I survived.
The days of diapers and teen-age rage

are gone, flicked by
fast-forward on the VCR.
Now comes the time to hold coats
close to the throat in winter,

the stiff, clipped steps
on icy sidewalks, dark hours
in a chair before birds sing.
Come, clasp my stiff knuckles

at the fireplace, bifocals off
for an hour. Rock softly
in my arms and hold me, girl,
this night won't last for long.

Home

Not when the wind
kicks up in the west
and turns the sky

blood-red, but later,
when fallout
powders all dark wood

is when the plains soul
feels at home.
Dust, and dust for hours

and watch it swirl
in a slant of light
and settle.

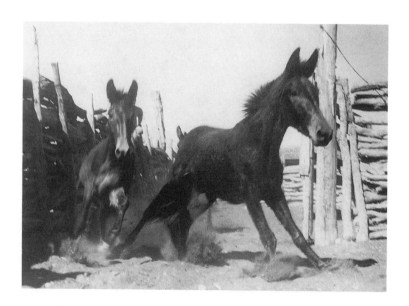

Getting It Done

I've watched amazed the same burnt sienna
land we live on begin to glow
under her brush, patches of ocher sand
glinting light she invents from nothing

but tubes and bristles. Weaving a delicate balance
down arroyos, she gathers and blesses
turquoise, obsidian, anything to bring color
to copper, making a garden of stones and cactus.

Even me, she polishes nightly with the roughest
of kisses, giving up on nothing
she's started, taking years and three children
to paint over and over this scene in the desert

where we live, only brown earth and sky
and in between, all that matters.

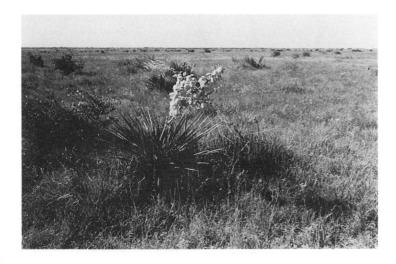

PHOTOGRAPHS

Unless stated otherwise, photographs in *All That Matters* were reproduced by Roger L. Wilkins.

138

140

Books by Walter McDonald

Poetry

All That Matters
The Digs in Escondido Canyon
Night Landings
After the Noise of Saigon
Rafting the Brazos
Splitting Wood for Winter
The Flying Dutchman
Witching on Hardscrabble
Burning the Fence
Working Against Time
Anything, Anything
One Things Leads to Another
Caliban in Blue

Fiction

A Band of Brothers: Stories from Vietnam

Books by Janet M. Neugebauer

All That Matters
Plains Farmer: The Diary of William G. DeLoach, 1914-1964